A coloring book by

Just Indi Creative World

Hello!

Thank you for choosing " Fairy Garden , Grayscale Coloring Book" from among the many coloring books available.
We hope that the illustrations have fully met your expectations and provided a fun coloring experience.
We are constantly striving to improve and provide the best possible product, and we would love to hear your thoughts
on the book.If you have a moment, please consider leaving a review to let us know how we're doing and help other people
make an informed decision. Your feedback is greatly appreciated and valuable to us.

———————————————

We love seeing the creative works that our coloring book inspires, and we would be thrilled to see your colorful
illustrations!
We invite you to share your artwork with us on our Instagram page @justindi_creativeworld. Simply tag us in your
post.
Your artwork may even be featured on our page, allowing others to appreciate your talent and creativity.
We can't wait to see what you come up with, so start coloring and share your masterpieces with us today!

———————————————

Amazon's paper selection is best suited for use with colored pencils and crayons. Wet mediums may cause bleed-
through, so it is advised to place a sheet of paper behind the page to prevent this from happening.

THANK YOU!

COLOR TEST

How to Color an Illustration in Grayscale

Coloring an illustration in grayscale can seem daunting, but it doesn't have to be. With a few basic tips and tricks, anyone can create stunning grayscale artwork! Here's a quick guide on how to get started:

- Choose a base color. Selecting one color as a base is a great way to start when creating a grayscale illustration. This will be used as a reference point for the other shades.
- Determine the range of shades. When creating a grayscale illustration, you can use a range of shades from lightest to darkest. This will help create depth within the illustration.
- Experiment with color palettes. Different colors can be used to give the illustration a unique atmosphere. For example, using a blue hue can provide a cool, calming atmosphere while using warmer colors can give it a lively, playful feel.
- Don't forget the details. Once the base colors have been determined, the next step is to add in details. This can include adding shadows, highlights, or other small details.
- Finalize the illustration. Once you are happy with the overall look and feel of the illustration, it's time to finalize it. This includes checking for any mistakes or issues, such as uneven transitions between colors, in order to ensure that the illustration is polished and presentable.

These are the basics of coloring illustrations in grayscale. With practice, you'll be able to create stunning artwork in no time!

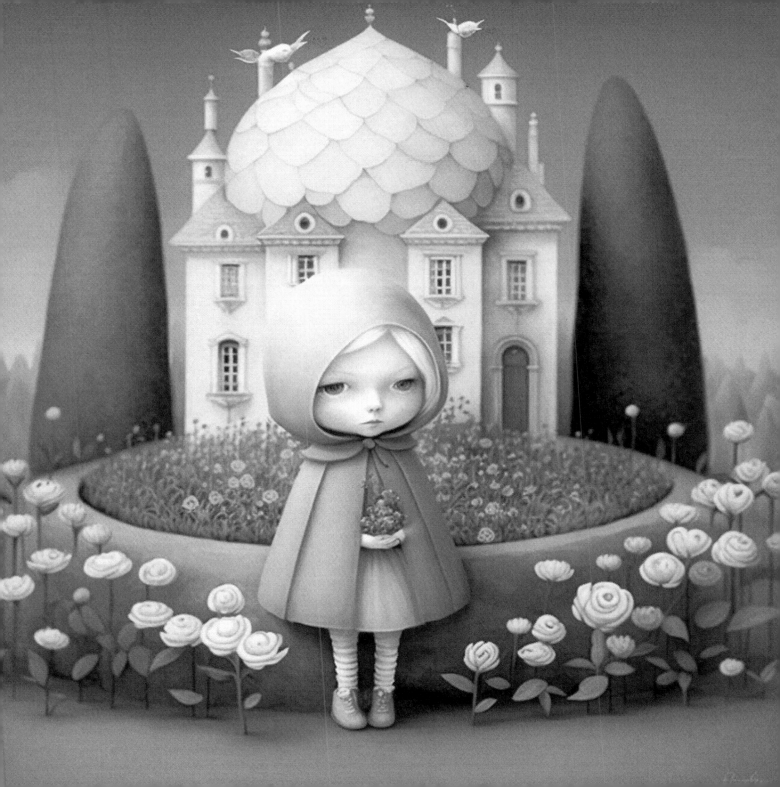

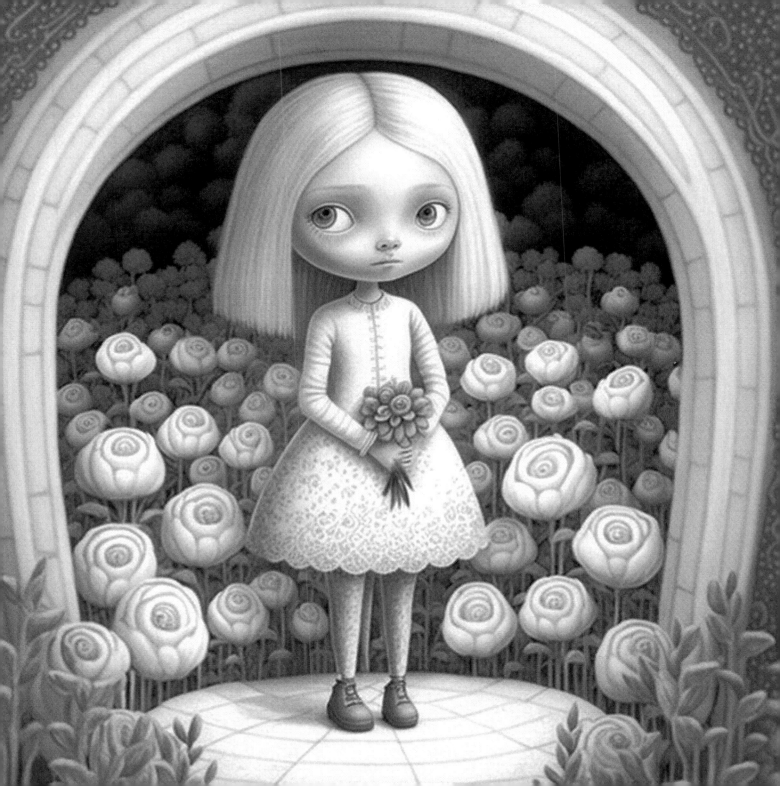

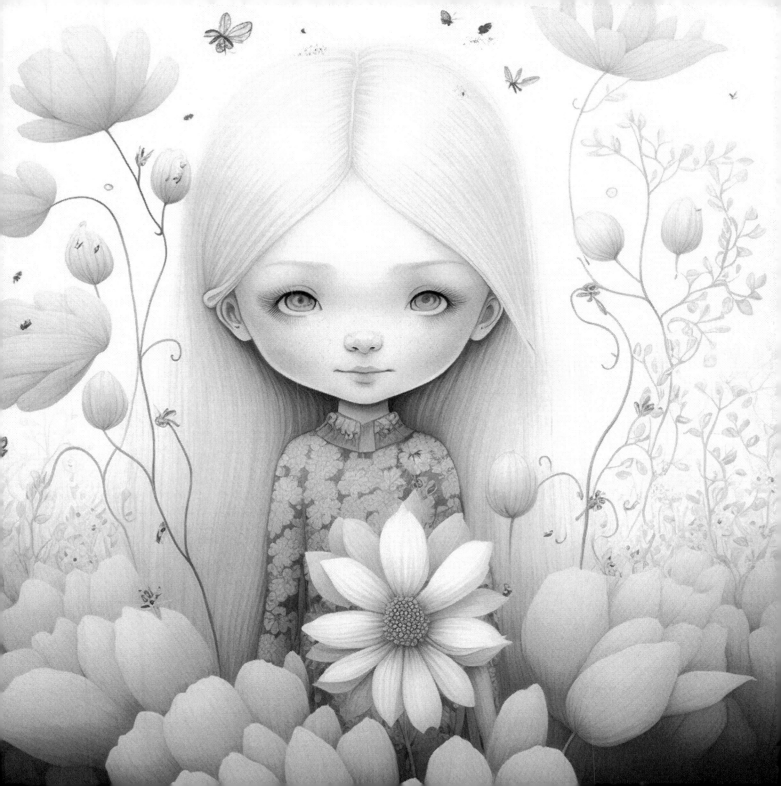

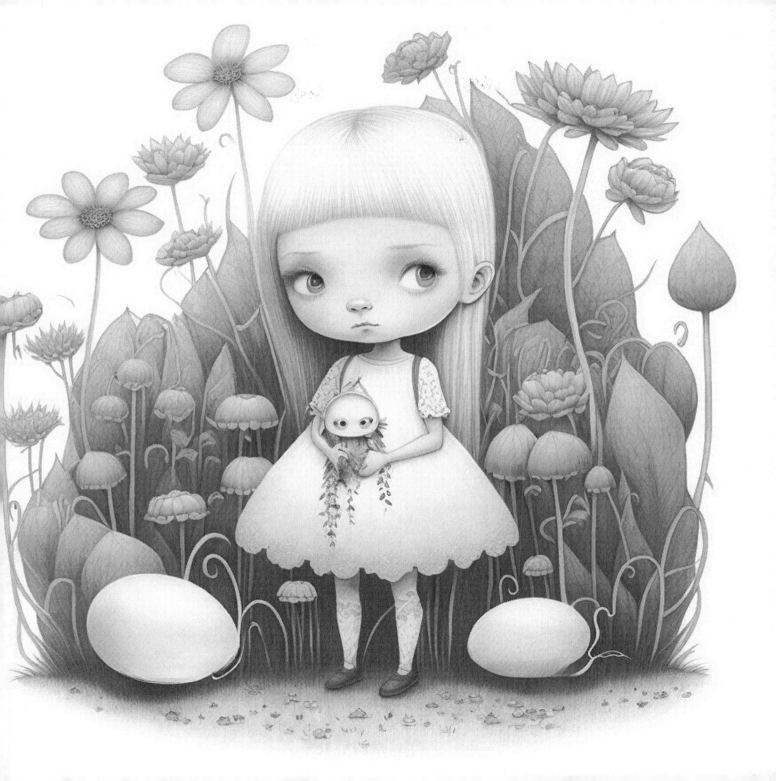

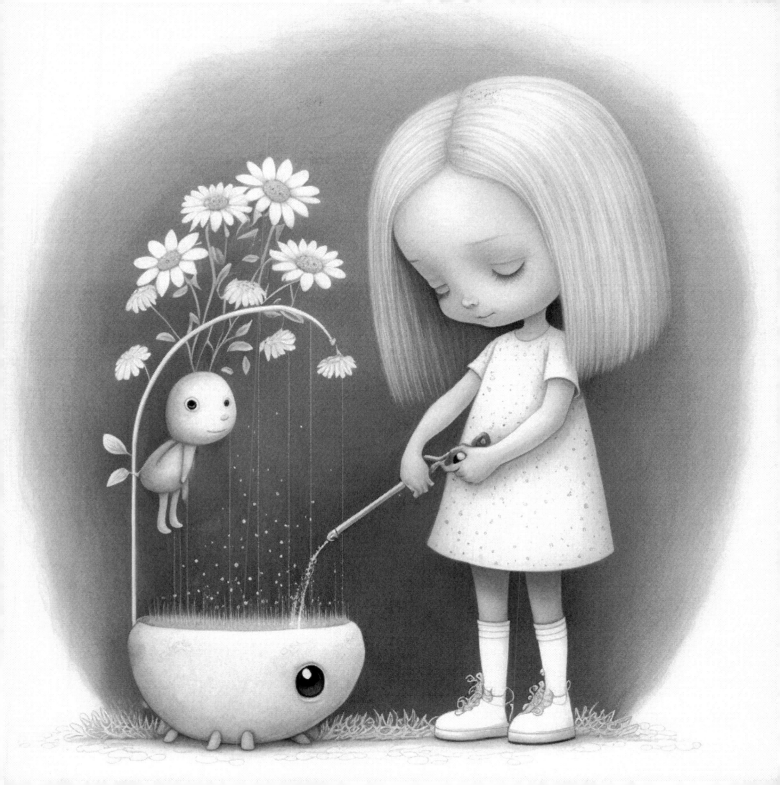

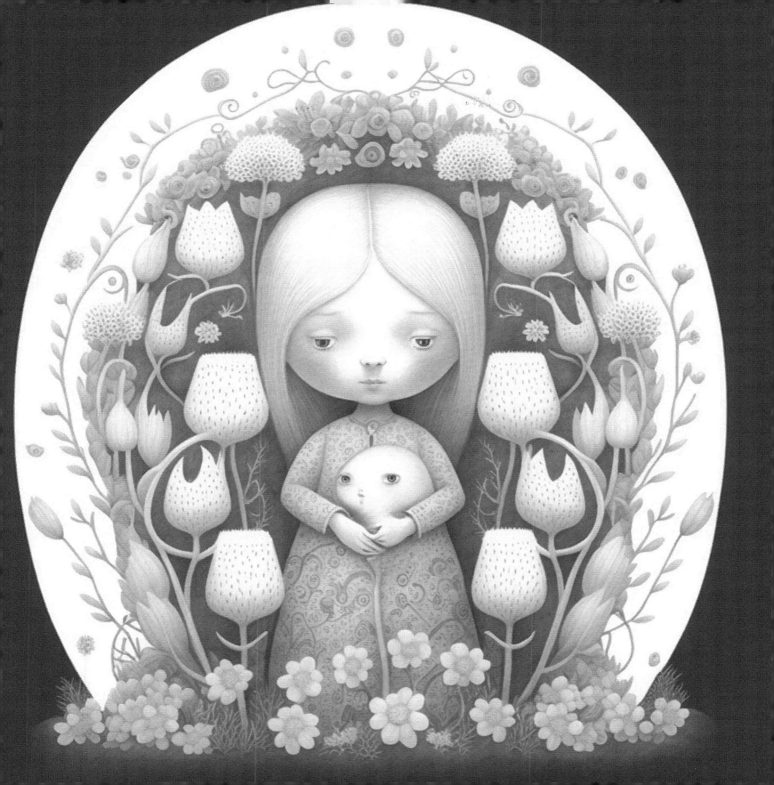

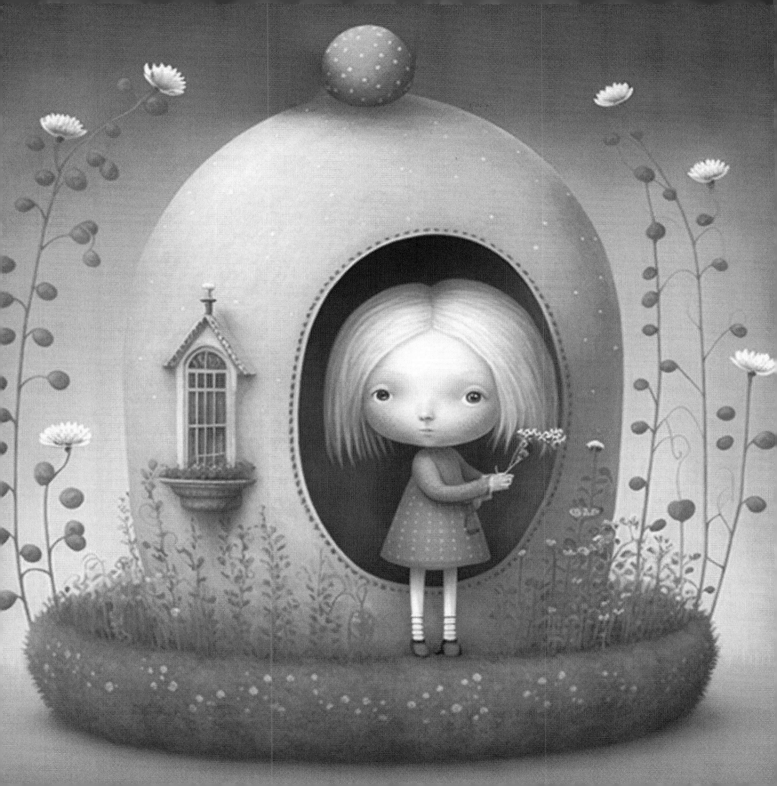

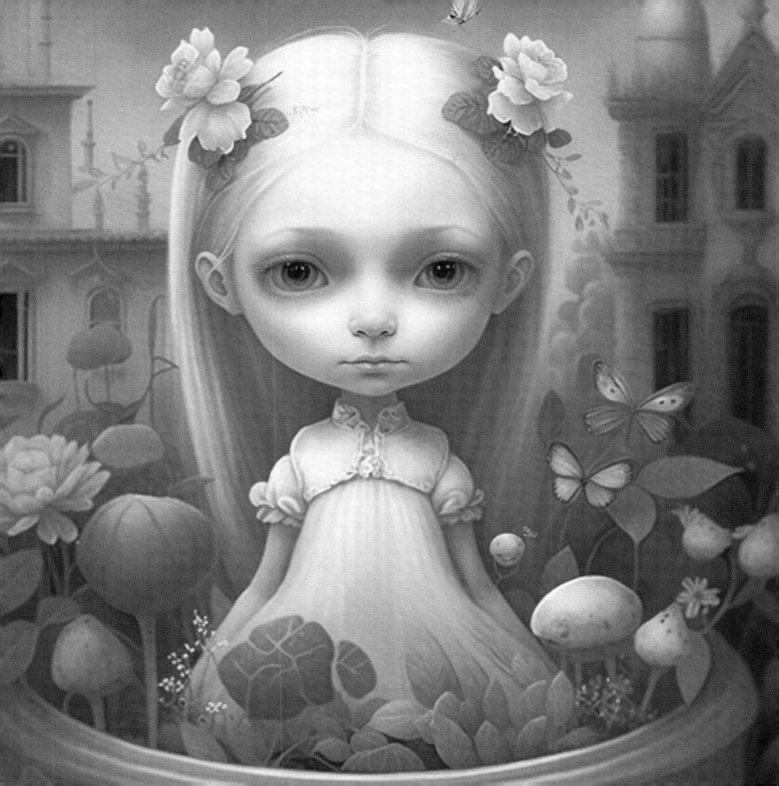

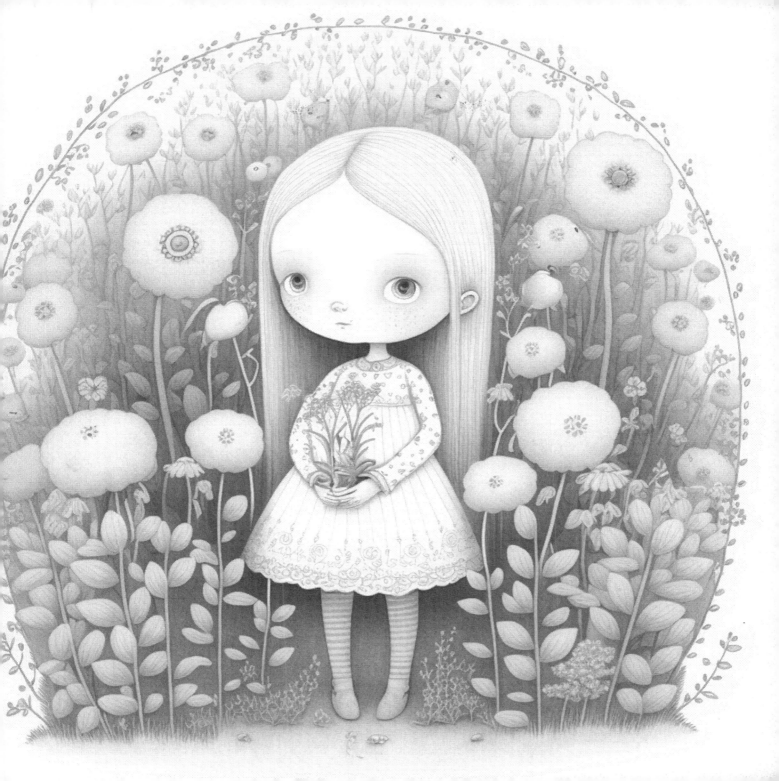

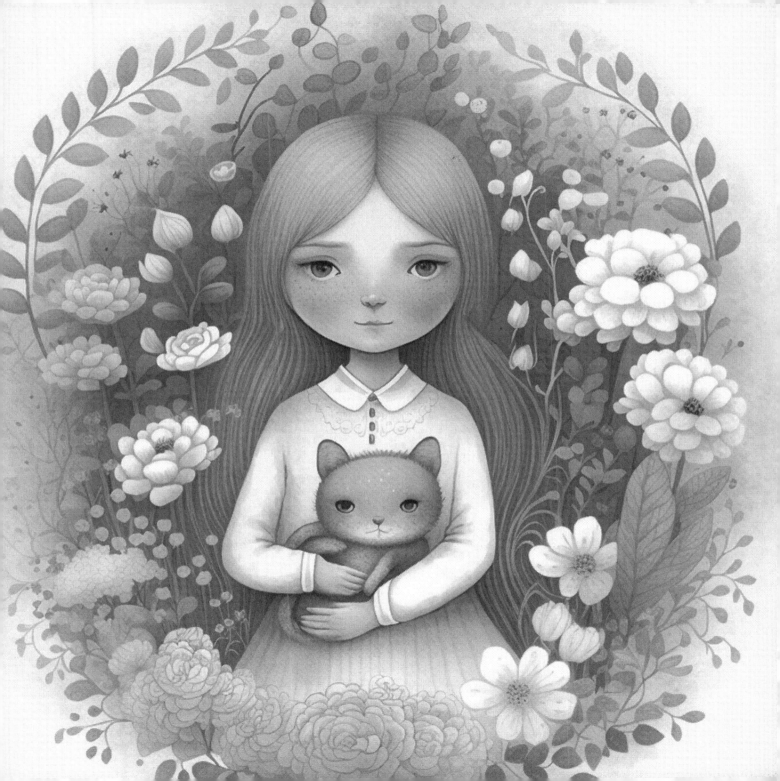

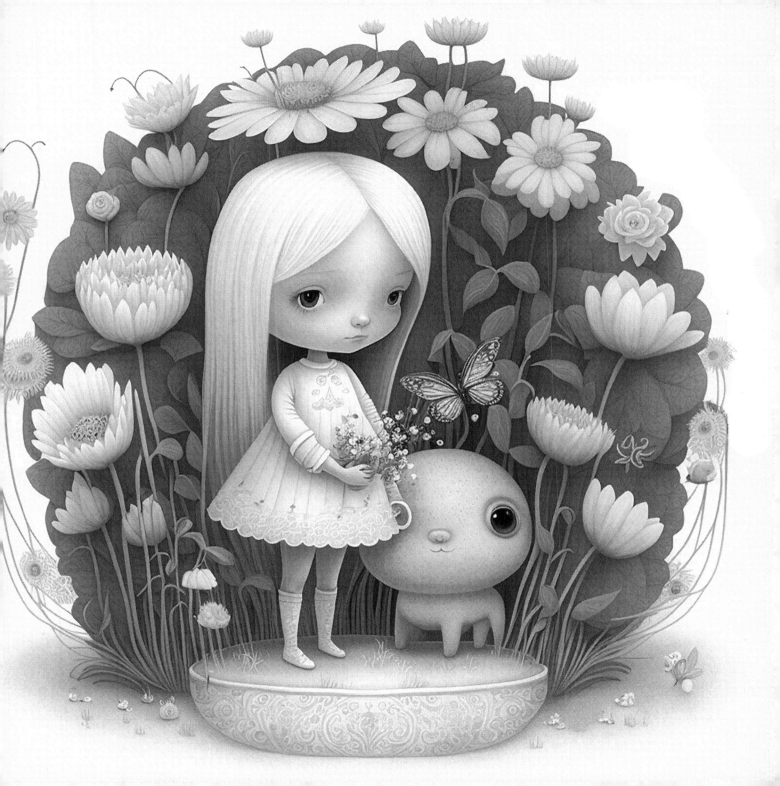

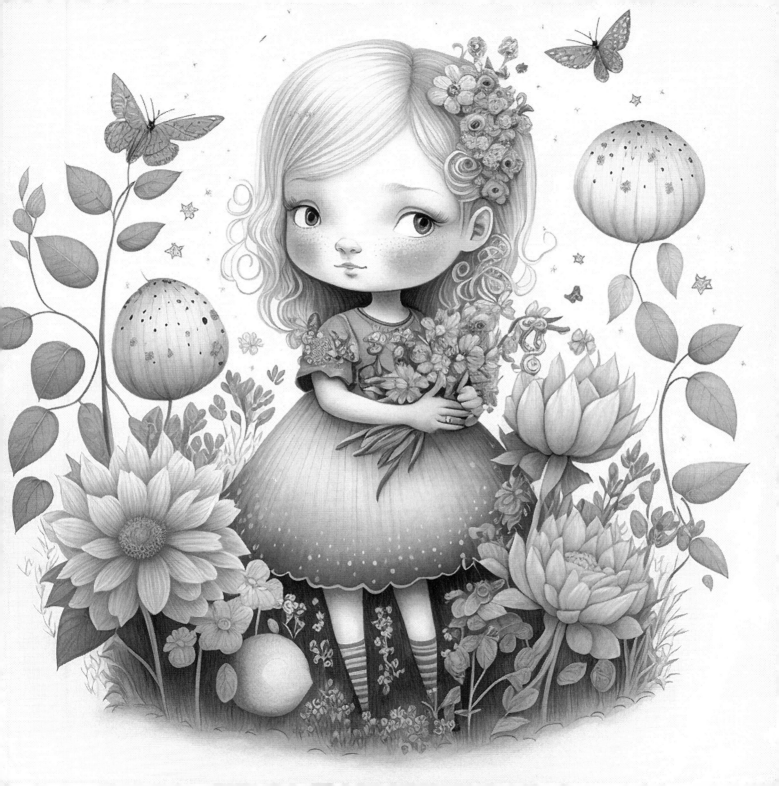

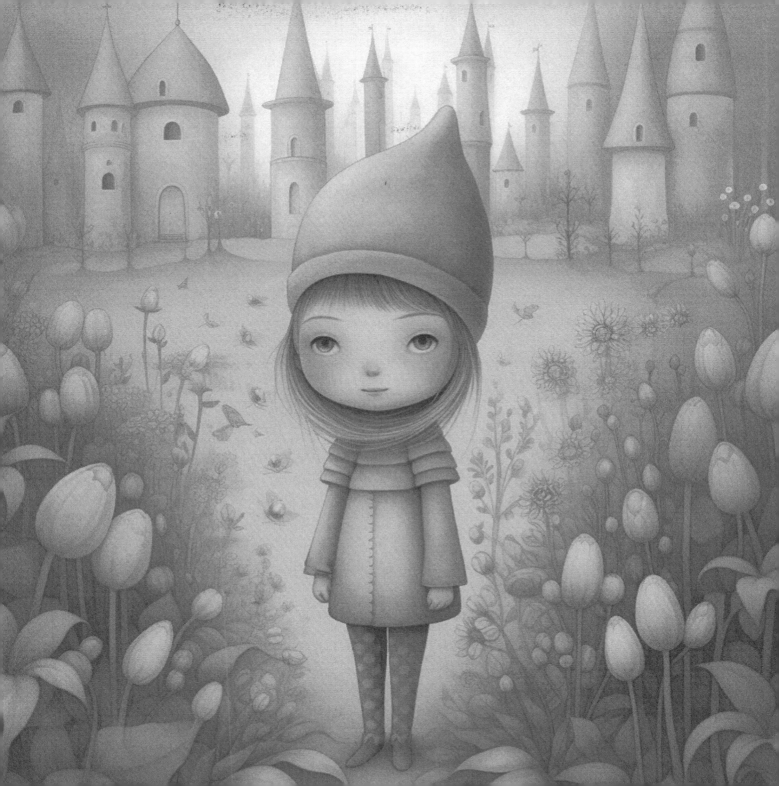

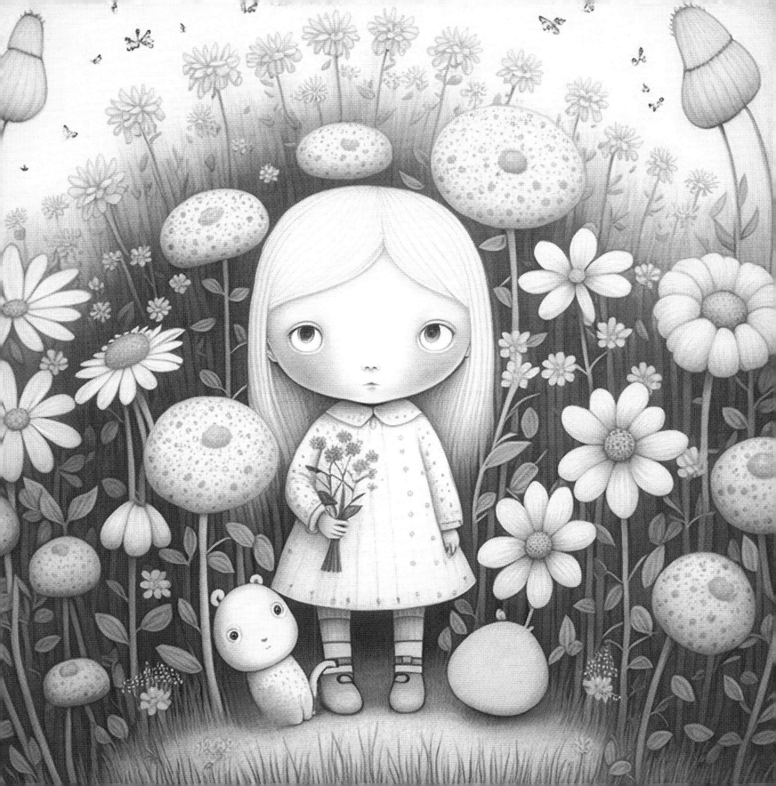

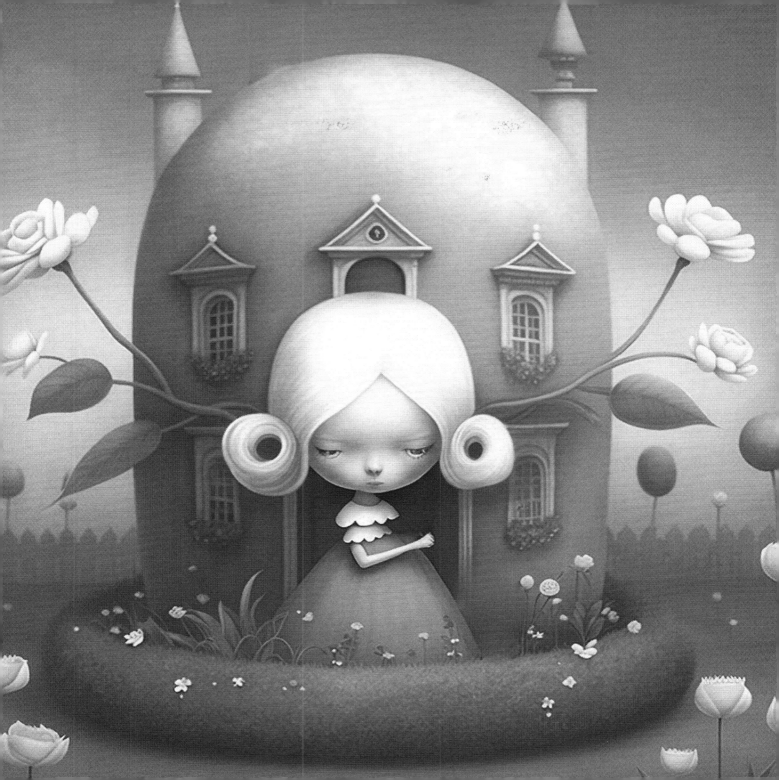

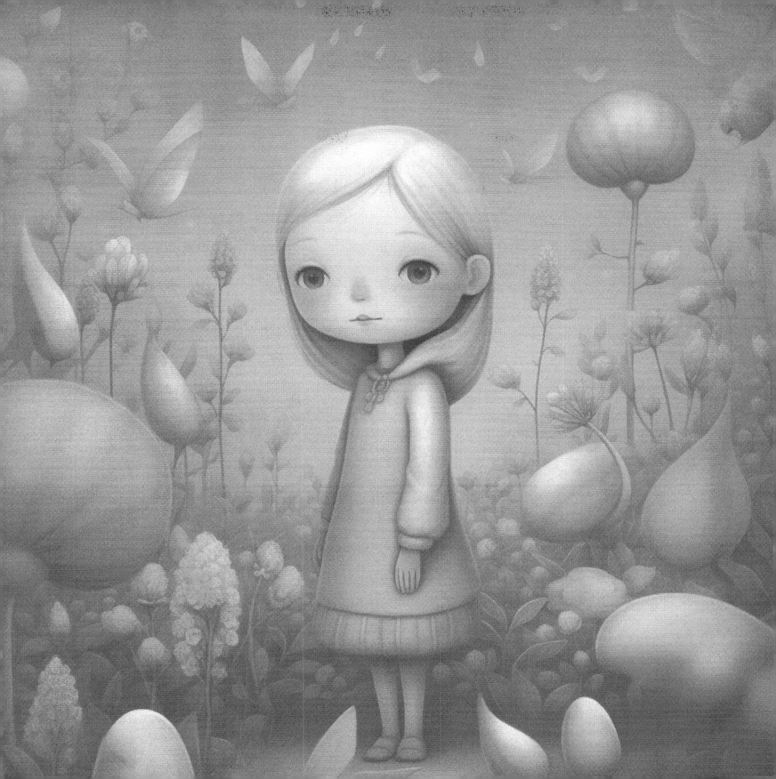

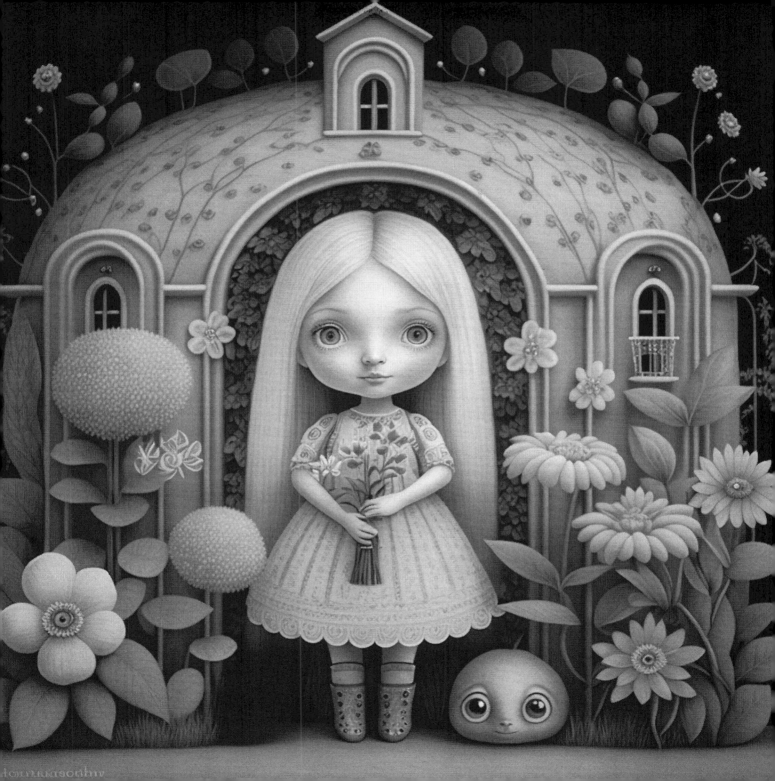

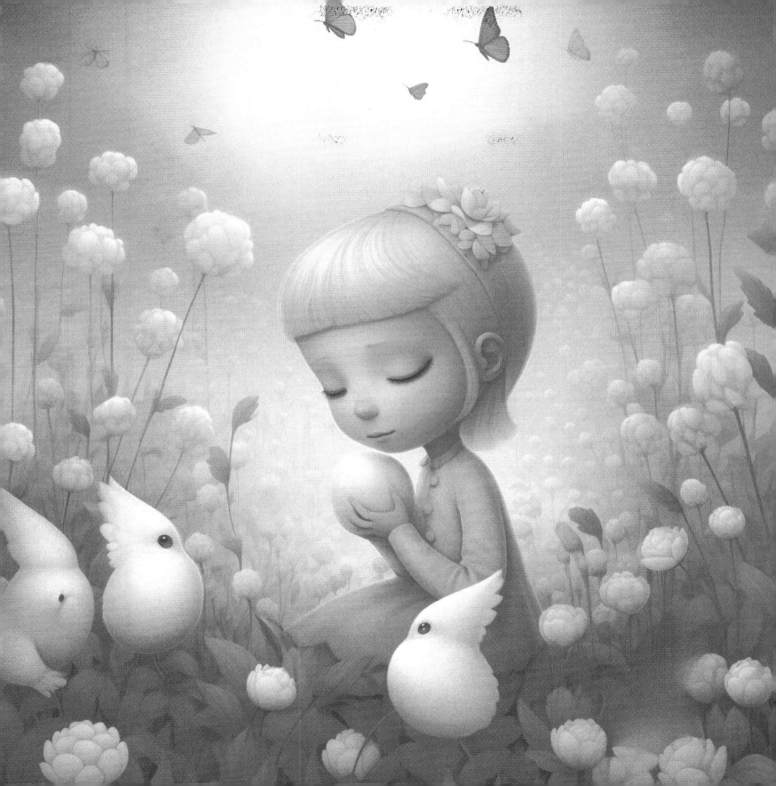

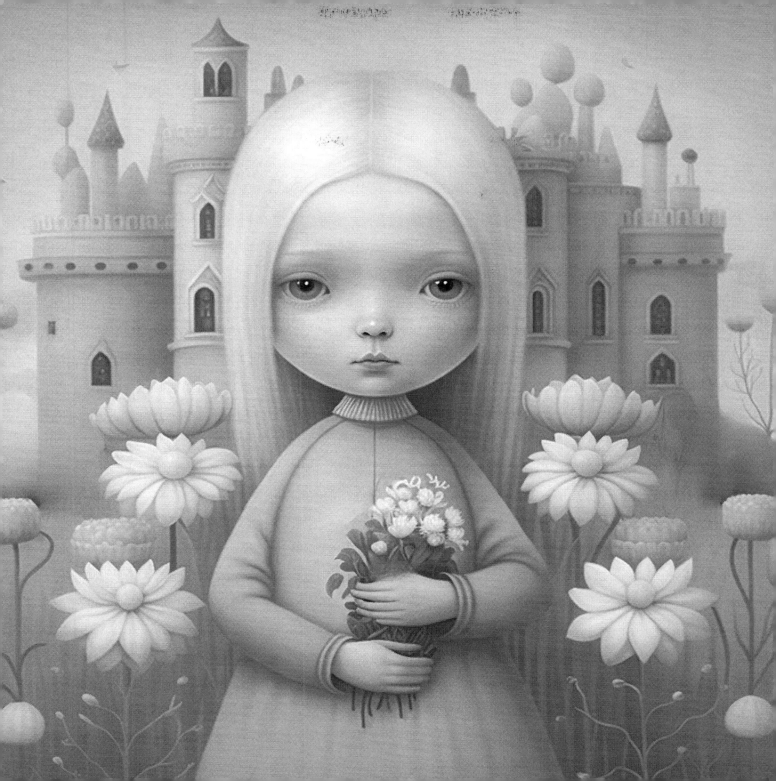

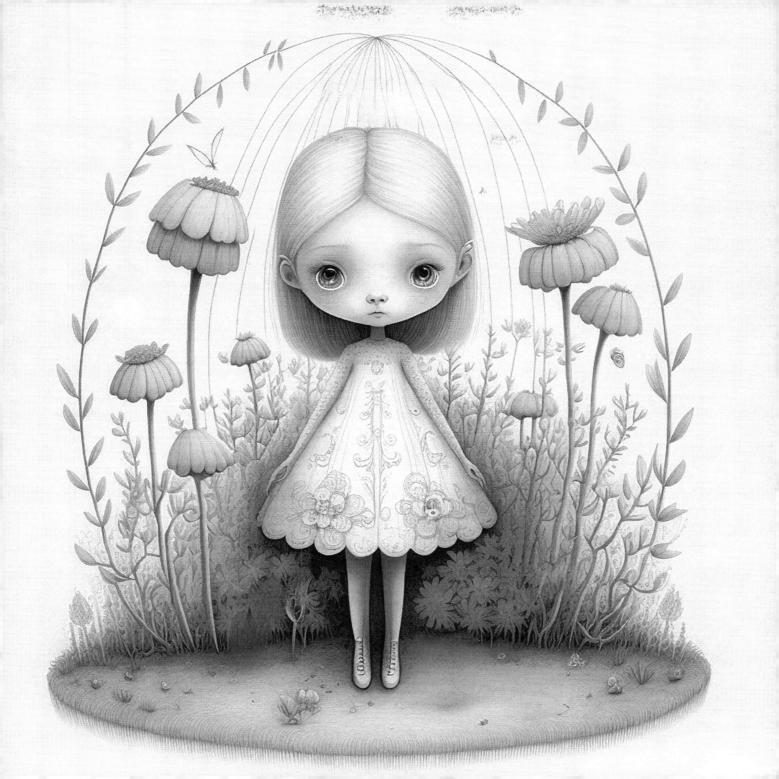

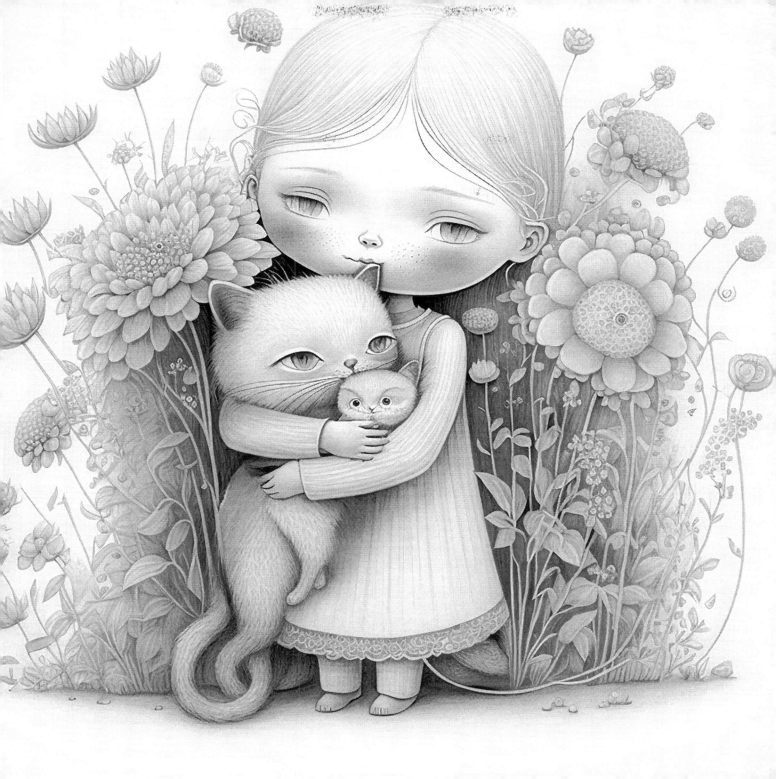

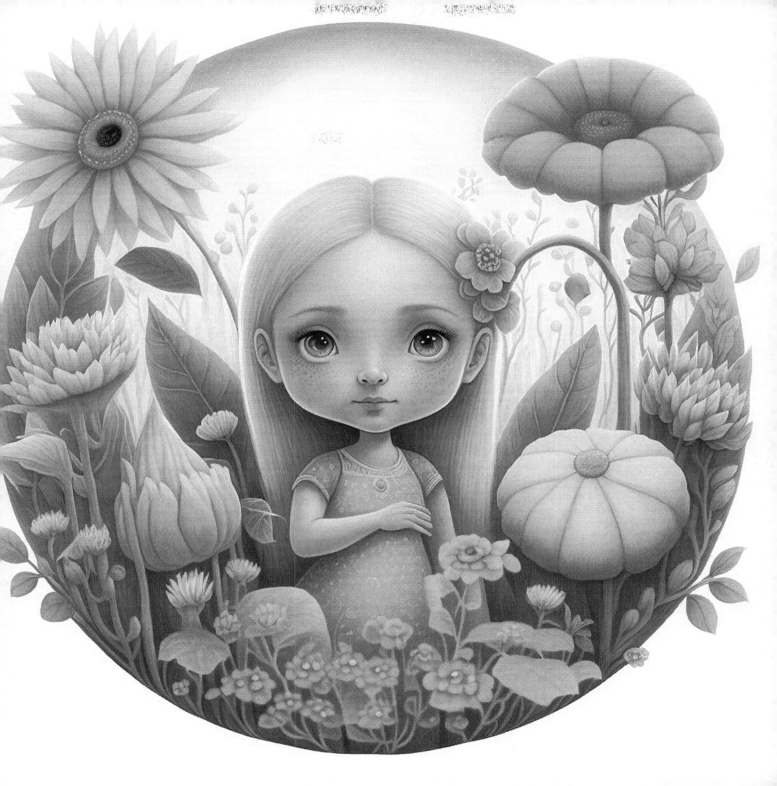

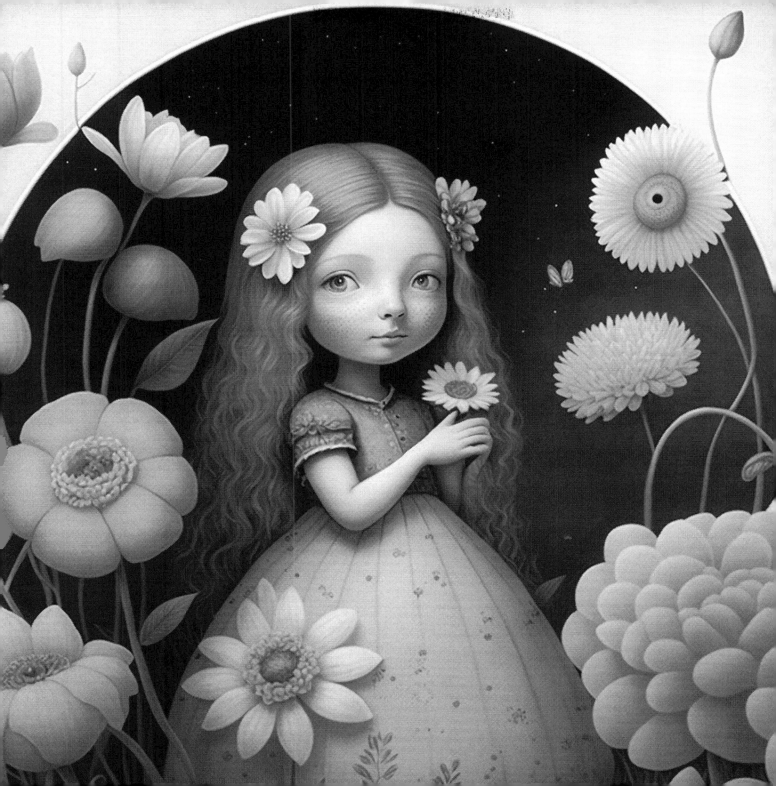

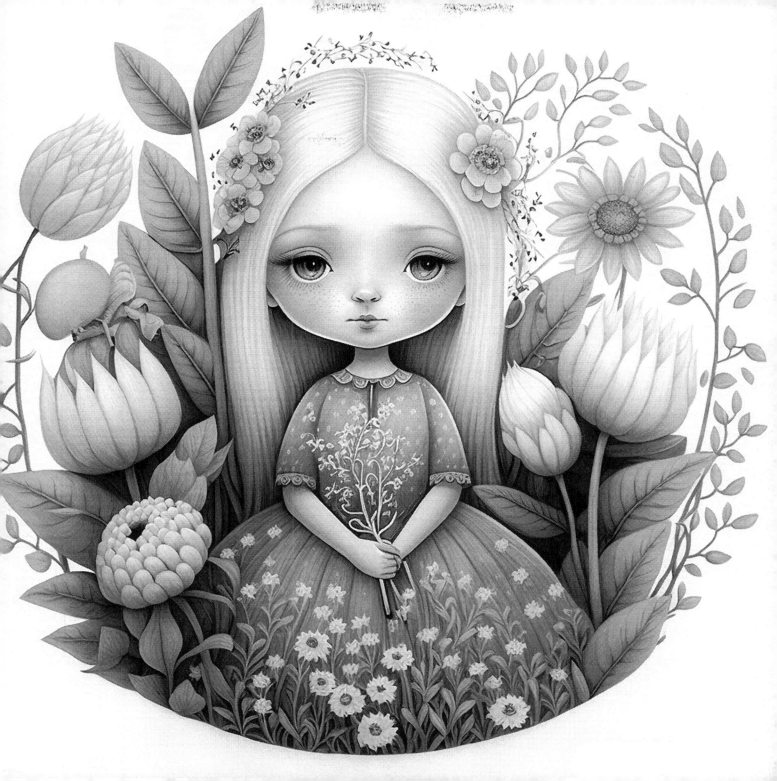

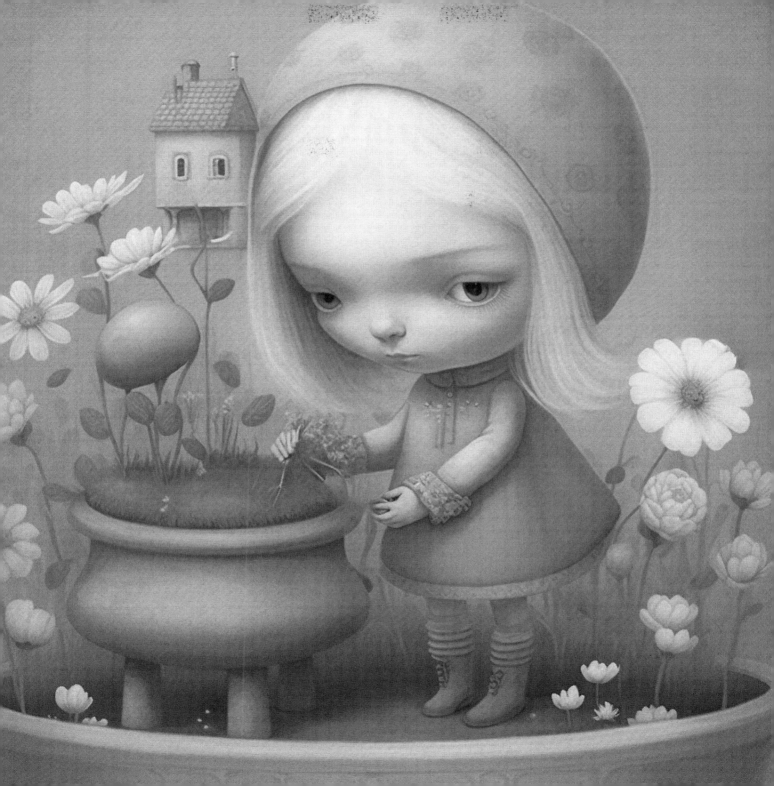

Check out these other titles in our collection.

"Dreams - Grayscale Coloring Book"
-Search on Amazon -
ISBN:
B0BRLVR62V

"Lovely Garden - Grayscale Coloring Book"
-Search on Amazon -
ISBN:
B0BRZ68D76

"Down the Rabbit Hole, Greyscale Coloring Book"
-Search on Amazon -
ISBN:
B0BSJLS6WC

"Big Eyes - Coloring Book"
-Search on Amazon -
ISBN:
B0BRC945S3

"Big Eyes 2- Coloring Book"
-Search on Amazon -
ISBN:
B0BS8XX6TT

"Unicorn Princess Coloring Book"
-Search on Amazon -
ISBN:
B0BSJLDGRK

"Weird Cats- Coloring Book"
-Search on Amazon -
ISBN:
B0BRJLZVCL

"Mushrooms and Roses: A Greyscale Coloring Book of Fairytale Houses"
-Search on Amazon -
ISBN:
B0BSJPYT7W

"Mermaids of The Deep - Greyscale Coloring Book"
-Search on Amazon -
ISBN:
B0BT3P5JN3

"End Of Our Days- Dystopian Coloring Book"
-Search on Amazon -
ISBN:
B0BQY289XD

"After The Fall- Dystopian Coloring Book"
-Search on Amazon -
ISBN:
B0BQY289XD

"Doll Fashion Fun - Coloring Book"
-Search on Amazon -
ISBN:
B0BRM2N1FV

"Ethereal Beauty - Coloring Book"
-Search on Amazon -
ISBN:
B0BS8XB7SV

"SneakerBots - Coloring Book"
-Search on Amazon -
ISBN:
B0BSJ5SVFR

"I ♡ Kawaii- Coloring Book"
-Search on Amazon -
ISBN:
B0BR5B2QCR

"Cute Alien Valentines - Coloring Book"
-Search on Amazon -
ISBN:
B0BRM23TW3

"Amazing Dolls - Coloring Book"
-Search on Amazon -
ISBN:
B0BRLVP5JV

"World's Beauty - Coloring Book"
-Search on Amazon -
ISBN:
B0BSWTBDBZ

Made in the USA
Columbia, SC
06 May 2023